751.4

21

Mixed Media

YOU CAN PAINT

Collins

WENDY JELBERT has painted from a very early age, and her three children as well as grandchildren do the same! She attended art school and studied fine and abstract art, pottery and print-making. She exhibits at the Century Gallery in Hartley Wintney, Hampshire, at the First Floor Gallery in Romsey, Hampshire, at the Wykenham Gallery in Stockbridge, Hampshire, and at the Burford Gallery in Burford, Oxon. She runs workshops in Hampshire and abroad. She has made five art instruction videos and written 14 books.

WENDY JELBERT

ABSOLUTE BEGINNERS
A step-by-step guide for

Mixed Media

YOU CAN PAINT

Collins

First published in 2002 by
Collins, an imprint of
HarperCollinsPublishers
77-85 Fulham Palace Road
Hammersmith
London W6 8JB

Collins is a registered trademark of
HarperCollins Publishers Limited

The Collins website address is
www.collins.co.uk

03 05 07 06 04 02

2 4 6 8 7 5 3 1

© Wendy Jelbert, 2002

Wendy Jelbert hereby asserts her moral right to be identified
as the author of this work.

**A catalogue record of this book is available from the
British Library**

Editor: Isobel Smales
Designer: Penny Dawes
Photography: Nigel Cheffers-Heard

ISBN 0 00 711853 8

Colour reproduction by Colourscan, Singapore
Printed in Great Britain by Bath Press Colourbooks, Glasgow

CONTENTS

Introduction 6

How to use this book 8

Basic materials 10

Making marks 14

Mixing your media 20

Fruit and vegetables 26

Still life 36

Form and composition 42

Flowers 48

Gardens 56

Trees 66

Seaside 76

Buildings 90

A mixed media riverside painting using soft pastels over watercolours

INTRODUCTION

Nearly all of my students, from an early age, have enjoyed scribbling and making marks. Some were lucky enough to be encouraged to progress to trying out crayons and real paints, and happily flourished. Others did not develop their art further then, but took it up again when circumstances arose in later life. Whatever their experiences, all students have one thing in common when they come to an art teacher: they are so eager to learn!

The great pleasure of mixed media is the freedom it offers. You are not rigidly confined by the 'rules' of any one technique. With mixed media you can explore many different ways of achieving a result, in a unique and personal way, making up your own rules as you go along.

To work successfully in mixed media it is not essential to be greatly accomplished in applying paints or pastels, but you will need an adventurous spirit and determination. Using mixed media involves working out balances and ingredients, not dissimilar to a cookery recipe, and, as in cooking, it is important not to overwork it or to add too much of one vital component, otherwise

you will get dissatisfying results in your finished painting.

As a teacher, I have come to realize that students do not require a lot of text, but need straightforward advice and guidance using step-by-step exercises and projects where each stage is demonstrated by the teacher. This book offers exactly this, and its aim is to help build your confidence so that you can try projects out for yourself. Progress comes with practice. Learning to mix and match your different materials is challenging and rewarding. There will be times when you make mistakes, but it is through these mistakes that you will learn. You are not necessarily producing work to exhibit or to hang in galleries (not at first anyway!) and you must try not to be influenced by other people's remarks and opinions. It is how you feel about your work that is important. If you please yourself, this pleasure will be echoed in your paintings. There are hours of fun awaiting you!

Anemones painted in oil pastels with watercolour

Ornate lantern painted using masking fluid with watercolours

This is an instruction book for beginners, aimed to help you at every stage from selecting the right materials to showing you how to use them to best effect. There are straightforward exercises and demonstrations for you to work through, broken down into simple stages that are easy to follow.

There is a bewildering choice of media available and here you will find advice on how to make the best choices. The book shows you how the different media can be used, and simple ways to mix them. It is worth spending time just experimenting with the materials to familiarize yourself with the way they work and the way they combine together before you try anything more complicated. The exercises and demonstrations include many of the subjects that are of most interest to a beginner and that are easily available: flowers, gardens, still life etc. Once you have copied these and are happy with the results, do have a go with a subject or objects of your own choice. Throughout the book I have used a selection of easily available materials. Keep your selection simple at first, for if you have too much choice it will become confusing. Try to avoid buying large sets of materials and use just a small selection of each. You will soon discover your favourites, and will be able to decide which materials to use to achieve the effects you want in future work. As you gain in confidence, don't just stick to your favourites, but try to keep an open mind as you may find that your preconceived ideas are easily expelled.

HOW TO USE THIS BOOK

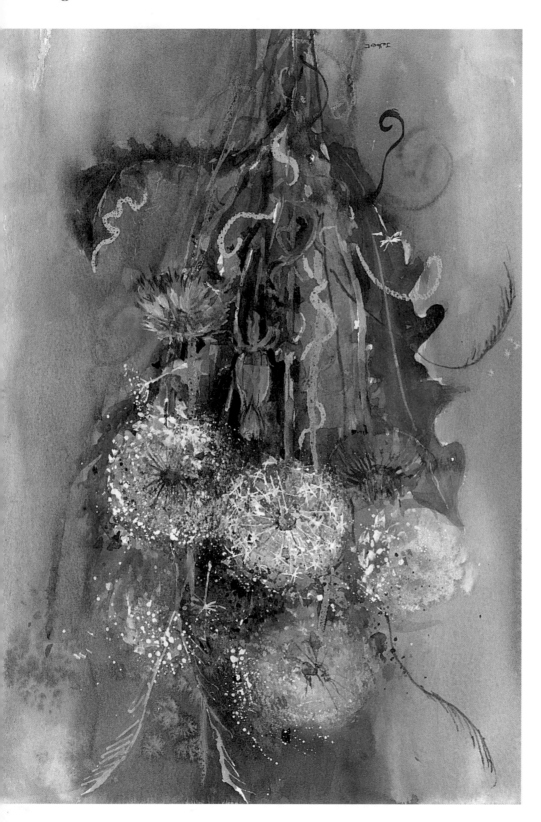

*Dandelion heads
painted in
watercolour with
masking fluid,
and soft and oil
pastels*

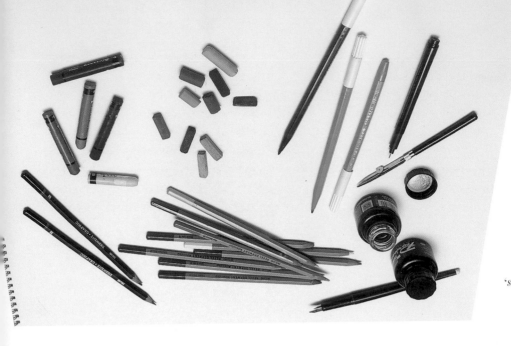

*A selection of inks,
watersoluble pencils,
pens and pastels,
both oil and
traditional*

BASIC MATERIALS

As a beginner, although you need to experiment with several types of media, you will not need an expensive or extensive range of materials to start with. Indeed, the fewer of each suggested material you have, the fewer you have to master! As you progress, you will find that you want to expand your range of pencils, pastels, inks and paints, but at the start it is best to keep things simple.

Pencils I recommend a small set of watersoluble or aquarelle pencils. If you buy them separately you can select the colours. You will also need a 2B or 3B (soft) pencil for general drawing.

Pastels You will need both traditional pastels and oil pastels. You can buy a 'cheap and cheerful' set of 2.5 cm (1 inch) long soft pastels from most art shops. Round pastels create soft effects whilst the square, firmer ones are good for fine details too. A set of oil pastels needs to contain the 'fatter' varieties as these are best as a resist to watercolours (they repel the watercolour paint and let the pastel colour show through), rather than the harder and smaller varieties. These may also be bought separately. Include some of the lighter colours such as pale cream, greens, greys, pinks and white, as these are ideal for our purposes.

Drawing pens These include felt-tips and fibre-tips which can be bought separately or in sets. The 'throw-away' drawing pens with steel nibs are excellent, and I recommend a black and sepia size 01 and 02 in waterproof and watersoluble ink. There is an excellent pen for sketching that requires cartridges: it is rather more expensive but well worth the extra: again, I use both black and sepia.

Brush pens These are waterproof and have a nib that acts like a brush with a seemingly never-ending supply of ink. Excellent for bold line work.

Coloured inks A set of these in pots: any make, and choose your favourite colours to try out. They can be applied with a dipper, a ruling/drawing pen or a brush.

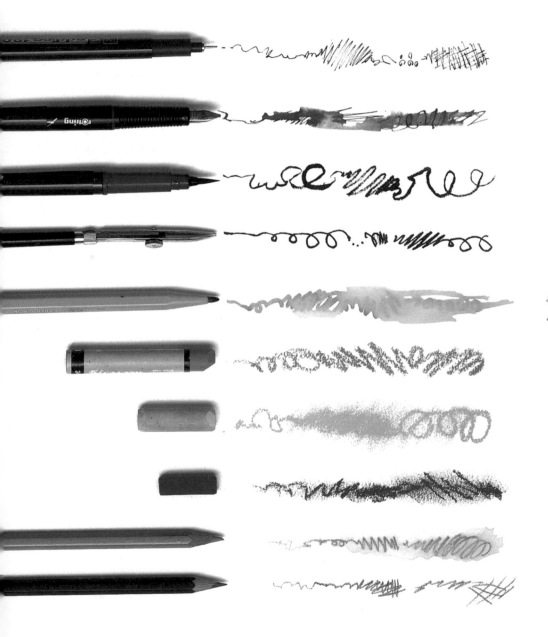

Here are the sketching and drawing implements used in this book, together with the marks they make

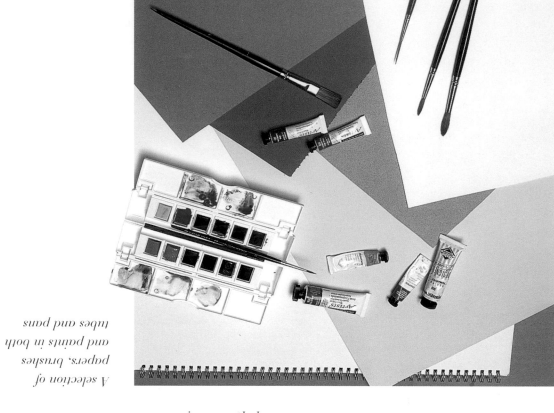

A selection of papers, brushes and paints in both tubes and pans

Watercolours There are two qualities of watercolour paints, Students' and Artists', and they come in both pans and tubes. I suggest that you buy a pan set of watercolours in Artists' quality. You can always add some more colours later on.

Just before you start work, always wet over the dry surface of your pans to prime them ready for painting. You will need to include the primary colours of red, blue and yellow, from which all other colours can be mixed, and I suggest that you also buy Yellow Ochre, Burnt Sienna, Cerulean Blue and a ready mixed green (Hooker's or Olive) plus a dark brown.

Brushes Although sable brushes are the best you can buy, the synthetic ones or sable/synthetic mix are ideal. I use a selection of the Daler-Rowney Dalon or Cryla brushes, no. 5 and no. 10 round-headed, no. 12 flat-headed and a rigger no. 1. The higher the number, the larger the brush.

Papers I like a 300 gsm (140 lb) watercolour paper for my mixed media work: it will deal with making alterations and correcting mistakes.

White gouache A thick 'covering' white paint, supplied in tubes: it may be used on its own or mixed with watercolours and is also useful for making alterations and correcting mistakes.

with anything you may throw onto it! Daler-Rowney's Langton watercolour Not (not hot-pressed) paper is excellent. This comes in spiral-bound pads 30 x 40 cm (12 x 16 inches) and blocks. Saunders Waterford Not surface is also ideal, or you could cut up a sheet of Bockingford 300 gsm (140 lb) and anchor it to a board with masking tape. If there is little watercolour used in your work, you can get away with a 190 gsm (90 lb) Not surface paper or pad.

For some of these exercises you will be using coloured papers. Heavyweight mountboards, scrapbook paper or Daler-Rowney's Canford in A1 sheets, or assorted coloured paper pads for the brighter colours are ideal. Some pastel papers would also be fine.

Masking fluid This is excellent for work with watercolour (see page 19). You will also need an applicator (a ruling/drawing pen or from an art or technical drawing shop). If the masking fluid is too thick, pour a little away and top up with water. It should resemble milk, not cream. In order for it to be noticeable when dry, add a pea-sized amount of blue or yellow watercolour.

Drawing board This is useful to secure your paper to. Masking tape could be used for this purpose.

Eraser Used for any small hiccups and for lifting areas for highlighting. Cut into small strips for tiny lifted areas.

Fixative There is a good odourless and ozone-friendly one made by Daler-Rowney, used to stop your pastel work from smudging.

Plastic palette This is useful for preparing watercolour washes.

Sharp craft knife Used to sharpen your pencils and to shave bits of colour from them to create different effects.

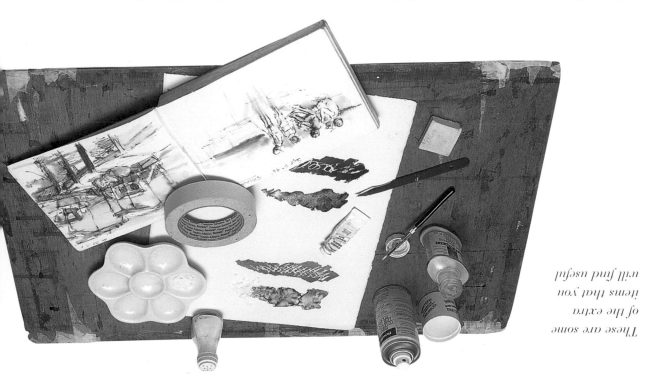

These are some of the extra items that you will find useful

MAKING MARKS

I suggest that you experiment with each of the media individually before you start mixing them together. You will get a feel for what they can do by making marks. Don't expect your marks to be identical to my scribbles and washes, and try inventing some of your own as you go along.

Traditional pastels

These examples are worked using two different coloured traditional pastels on white paper. Pastel work needs a spray of fixative to prevent it from smudging.

Break the pastel and make a light stroke using the sharp edge for a thin line (left), use the end for a middle line, and drag the pastel on its side for the thickest line (right).

Block in one colour, trying to obscure the individual strokes.

Drag a band of one colour against the other, then blend them together with a finger.

Apply a pastel with heavy pressure at the top, moving downwards and decreasing the pressure to give a graded effect from dark to light. Note the texture of the paper showing through. Repeat, but blend with a finger.

Using small, stabbing marks try intermixing the two colours.

Repeat the process, but using dots of both colours.

Try out a series of sweeping designs by twisting and curving the pastel with heavy and light strokes. This loosens up your wrist.

Traditional pastels on coloured paper

Coloured paper offers an exciting surface for pastels. You will need three different coloured pastels for these examples.

a) Gently apply feathering strokes in one colour and smudge it, follow it with a second colour and smudge this, leaving some areas untouched, and add some strokes of the third colour.

b) Wiggle a series of colours overlapping each other. Build up the area, leaving some paper showing between the shapes.

c) With definite sideways strokes apply a series of contrasting thick and thin hard-edged markings.

Oil pastels

These will feel different from traditional pastels, but initially their markings are similar. These examples are worked using some coloured paper and three different coloured pastels.

a) Combine coloured blended areas over and under feathering strokes.

b) Make lines and dots using different parts of the pastel.

c) Scribble areas of different colours and then gently blend some of the colour together creating an effect similar to a watercolour wash.

d) Use different pressures to create a graded effect.

e) Try out sweeping movements with curling strokes, applying different pressures.

f) Cross-hatch one colour over another, and blend some of the pattern with a finger.

Watercolours

If you practise the basic essential techniques needed to apply watercolours, you will soon discover how the washes behave and how your brush, paper and paint act together. These exercises use three colours.

Wash. *The colour needs to graduate smoothly from dark to light. Practise on dry paper (as here) and on wetted paper. Gradually add more water to the colour in your palette to make it lighter as you work up from the thicker and darker first stroke.*

Soft and blended edges. *Wet the whole area, and place in a light centre, then slowly add darker colours to the outside, using plenty of water.*

Graded colour wash. *Work the same as the graded wash, but start at one side and blend in another colour as you work over to the other side. Keep your paint watery.*

Lifting out. *To create an area of light within your watercolour wash, lift the area out using a dry tissue or brush. There will be some staining, and some papers are better than others for lifting out.*

Wet-into-wet. *This is where you place wetted colours onto a wetted surface and let them diffuse into each other. Practise rocking the paper to create some 'happy accidents'.*

Blocking in and brush strokes. *Fill in a square, blending to obscure the individual brush strokes. Then apply a variety of strokes using a brush on its side, edge and tip. Finally, dry the brush with a tissue, and try some dry brush strokes.*

Watersoluble coloured pencils

These are very portable and wonderfully versatile. They can be used dry and wetted: markings can be diffused using a brush or fingertip to give wash effects, and when the paper is dried more drawing or washes can be applied over the top.

Draw simple lines of colour, trying out one, two and three colour cross-hatching. Partly wet these, using a brush, then carry the wash onto the paper.

Dip a pencil into the water and twist so that the pigment is applied both wet and dry onto the paper.

Build up the colour gradually using a series of feathered layers, then use a brush to wash over half. Notice the differences in tone created.

The darkest mark that can be obtained from a pencil is by placing a wetted pencil tip on wetted paper. When dry, apply a pale pencil such as cream or white to give a glazed area of light.

Dip a pencil into the water and apply a doodle to the paper. Wash over it: the wetted pencil becomes indelible.

Wet the paper surface and scrape in splinterings of the pencil with a knife, then wash over. You can repeat the process to intensify the tone.

Wet some of the paper then pat the end of a brush over a wetted pencil to splatter the colours. This may need practice! Note the different effect in the wet and dry areas.

Hold several coloured wetted pencil points together and blend them on a brush (like a palette), then transfer them onto a wetted surface to diffuse together.

Ink pens

Cartridge, felt-tip, fibre-tip or steel-nibbed marker pens are all excellent for mixed media work. Try out various types by several manufacturers to see which you prefer. You can buy waterproof or watersoluble sepia and black and a range of other colours, but it is best to keep your selection simple at the start.

Draw some lively lines with watersoluble fibre-tip pens and coax some of the colour out in washes. See how the colours change when the water is added.

Scribble with a watersoluble pen then float water over the drawings. Add more pigment to give dense areas, then trail some thin penwork. Notice the differences in the tone created.

Try out a waterproof steel-nibbed pen, to see how useful it is for fine and detailed work.

Try some further work with a steel-nibbed pen: notice how varying the line thickness requires careful redrawing.

Combine several of these methods to create an exciting contrast of inks.

Use a brush pen for swift dramatic and bold full lines. Experiment with the pressure and a variety of twists and turns.

Masking fluid

This is used to mask off selected areas of a painting when a wash is being applied over the top. It can be drawn on using an applicator (a ruling/drawing pen) in a tight and delicate design; or flicked on using an old brush for a more random design. Add a drop of watercolour colouring to the fluid if it is colourless so that you can see where you have applied it. Let it dry thoroughly, add a watercolour wash and let this dry before rubbing the masking fluid off with your fingers.

Draw a design with masking fluid in a ruling/drawing pen. Let it dry, then wash over the top. Let this dry and rub off the masking fluid to reveal the first drawing on the white paper.

Paint an undercoat in one colour and let it dry. Apply a design in masking fluid, and once this is dry wash over with another colour. When this has dried, rub the masking fluid away to display the drawing with the first colour gleaming through.

Salts

These offer a lovely effect when sprinkled into a very wet watercolour wash. Different salts give different effects, and this technique is marvellous for snow, seas and foliage. Once the paint and salt are dry, the excess salt can be rubbed off.

The pebbled design is formed using dishwasher salt.

A different design created using flake salt.

This mottled or 'sponged' effect is created with rock salt.

These small dotted markings are formed using table salt.

MIXING YOUR MEDIA

Now that you have tried the basics, you can move on and start mixing your media to create different effects and textures. You will need to practise using different combinations of media to create the various surfaces and forms that you want for your pictures.

Watercolours with traditional pastels

Try these examples using soft traditional round and square pastels and watercolours on watercolour paper. These may be fixed with fixative spray.

Paint a watercolour wash, then draw in dry pastel and, with a drawing motion, mix both colours roughly together.

Let a watercolour wash dry, then draw over the top with pastel.

Repeat, but when dry, place contrasting broken lines on both surfaces to unite the whole picture.

Draw with square pastels and cover with a wash. These pastels are not as soft and will resist areas of the watercolour.

Gently merge soft pastel into a watercolour wash, so that it resembles a wet-into-wet wash, keeping some of the pastel dryness at the edges.

Paint a graded watercolour wash, and draw into the surface with pastels, merging them in places with the wash.

Watercolours with oil pastels

The larger, softer oil pastels are best to use as a resist to watercolour work: they repel the paint so the pastel colour shows through.

Lay on a watercolour wash. Allow to dry thoroughly; then apply oil pastels in broken and fine lines.

Use an oil pastel on its side leaving some paper texture exposed beneath, then apply watercolour over the top. The pastel is always brighter when applied directly to the paper.

Repeat, but using different pastel marks such as dots and dashes.

Apply some white pastel marks over and under a watercolour wash. Where the white has been placed over the wash it stains slightly, and is more vibrant where it is applied straight onto the paper.

Cross-hatch lines of different coloured pastel to give a vibrant pattern when covered with a watercolour wash.

Combine a graded watercolour wash with a network of dense and trailing pastel markings to give a lively mix of colour and contrasts.

Inks with watercolours

Combining inks with watercolours is probably the most traditional mix of media, but it is very flexible. Experiment with these two media to discover some additional effects for yourself.

Draw a web of waterproof pen marks, allow to dry, then paint a watercolour wash over it.

Repeat, this time using a watersoluble pen to see the different effect.

Draw some marks with a brush pen, allow the ink to dry thoroughly then paint over a yellow wash. If the ink is not dry it runs freely similar to a watersoluble ink.

Draw some lines of both waterproof and watersoluble pen, apply a wet-into-wet wash over the top.

Draw some felt-tip spirals, then wash over to give a diffused and misted effect.

Use the same pens in a series of lines into a wetted wash, and work over the top as it dries.

Pencils with inks

These media can be combined to give a variety of effects, from diffused loose drawings to glazing over the ink.

Work a wash of watersoluble pencil, then loosely draw with a felt-tip pen into the wet wash.

Draw some circles with watersoluble ink then wash over with a watersoluble pencil wash.

Cover waterproof ink marks with a watersoluble pencil wash, loading one side of the brush with yellow, the other blue.

Draw circles using a waterproof brush pen and cover with a pencil wash.

Draw circles as before but add a loose scribbling of pencil work over the top.

Drop coloured inks onto a wetted surface. When dry, glaze over the top with yellow pencil.

Pastels with inks

These exercises could also be tried out on coloured paper to give different results. Using similar colours gives a harmonious feel, and contrasting paper provides more dramatic effects.

Fill in some dark and definite brush pen drawings with loose pastel colours.

Softly smudge an area of pastel then draw into it with a waterproof pen.

Draw shapes in watersoluble ink, water it down then etch other shapes into it with pastel.

Interleave pen lines and pastel strokes, gradually altering the spacing and thickness of the lines.

Smudge together several pastel colours. Draw over with watersoluble inks then brush water over selected parts.

Draw a design in oil pastel then apply a wash of water-soluble ink, taken from the pen nib with a wetted brush.

Watercolours with pencils

This lovely combination of drawing and painting techniques enriches any work, and can be used to good effect in natural forms such as the leaves below.

Paint a leaf in watercolour and add pencil details on top.

Convert some blobs of watercolour into massed leaves by adding pencil outlines. Add quick branches with a dark brown pencil.

Sandwich a series of watercolour washes between wet and dry pencil scribbles.

Draw in some leaf veins with masking fluid, then cover with a watercolour/pencil wash (using a brush on the tip of the pencil). Rub the masking fluid off. Finally, add some watercolour 'spattering', and a dry application of pencil to give a warm glow to the leaf.

Scribble into a wet watercolour wash with dry pencil. This diffuses some of the pigments at various stages of drying.

Allow a watercolour wash to dry, then lighten areas with dry pencil work.

FRUIT AND VEGETABLES

The natural forms of fruit and vegetables make them ideal subjects for the first step in practising mixed media work. They are easily available and very varied, displaying a wide range of colours, textures and shapes.

Shiny cherry

First of all, let's try a very simple project: creating a shine on these cherries, using four different techniques, each giving a slightly different result.

Paint the cherry (using Alizarin Crimson and a little Vermilion). Apply a gentle shine with a dry white watersoluble pencil.

Paint the cherry, then draw the highlight on the dried paint with a pale cream or white oil pastel. The pastel could be drawn first as it would resist the red paint.

Use masking fluid for the shape of the highlight, then paint the cherry over the top. Once this is dry, rub the masking fluid off.

Add a bright, convincing shine to the cherry by painting on a highlight of white gouache.

Vermilion

Alizarin Crimson

Watercolours

Rosy apple

Apples vary in colour and patterns and are relatively easy to paint. You can make them more of a challenge by cutting them in half to expose the core with its seeds.

1 *Draw the shape of the apple in violet pencil and fill in the area of the fruit with a very wet yellow wash.*

2 *Use a graded wash technique, adding some red, to give the apple a rounded feel.*

pencils

watercolours

violet

Cadmium Yellow Vermilion

crimson

3 *Lift out a highlighted circle near to the stalk. Add the stalk using a wetted violet pencil. Draw in the assorted contrast markings using a crimson pencil at different pressures.*

Succulent strawberry

Strawberries always make my mouth water. Their textured surface makes them interesting to paint. The leaves are a delightful contrast, like a green hat!

watercolours

Olive Green

Vermilion

Alizarin Crimson

soft pastels

orange

pink

1 Draw the strawberry in pencil. Paint in the top using green mixed with a little Vermilion.

2 Block in the fruit shape with Vermilion.

3 While the paint is still wet, drop in some Alizarin Crimson to darken the colour to show form. When completely dry, apply dots of soft orange and pink pastels. Spray with a fixative if required.

Mouthwatering melon

By cutting this fruit open, you will be painting a different, more complicated shape, and adding the details of the seeds, flesh and skin.

1 *Sketch in the main shapes with a violet pencil, and draw over the details with a sepia pen, deepening some of the shapes between the seeds.*

pencils

yellow ochre · violet · cadmium yellow · orange · blue

pen sepia

2 *With an orange pencil, fill in the seed pad, and use a lighter tone for the flesh area. With heavy pressure, accentuate the skin design and shade in cadmium yellow pencil around the inner skin and yellow ochre on the outer skin.*

3 *Intensify the skin by adding water then applying more pencil work after this has dried. Shade over the flesh area again with dry orange pencil, watering this down to intensify the texture and colour. Anchor the image down using a blue pencil wash and some loose scribbles for the shadows beneath.*

Papery onion

Onions are an excellent example of the way lines can be used to explain and accentuate a structure, and to add texture.

1 *Draw the onion with a pencil. Apply masking fluid in lines that separate out and give the onion a good rounded shape, and wiggle in some roots. Apply a little watersoluble sepia pen to the top and bottom.*

2 *Fill out the body of the onion using a yellow and brown wash, and let the shadows form from the brown ink where it dissolves in the wash. Paint in a blue shadow so that the onion 'sits' on the ground.*

3 *When dry, rub the masking fluid off, and use the sepia ink to redraw some of the lines and roots.*

watersoluble
pen
sepia

watercolours

Yellow Burnt Cerulean
Ochre Sienna

Curly cabbage

When you cut a cabbage in half, the tightly packed layers of leaves create extraordinary designs that are fun to paint.

1 *Draw in the main body of the cabbage in pencil, then ink this in with a black brush pen. Start painting in the leaf patterning with green watercolour.*

2 *Continue to paint the complex design in a variety of different widths of green, adding more water to the colour to obtain assorted tones.*

3 *Complete the green of the cabbage then apply wiggly lines of cream pastel to give the paler areas.*

brush pen
black

watercolour
Hooker's Green

oil pastel
cream

Orange and green gourd

Gourds come in a diverse range of shapes and sizes, and are so hard and shiny that they look as if they are ceramic ornaments, or even as if they are made of plastic.

1 *Draw in the gourd with a blue pencil and apply a peppering of stabbing marks with a light green oil pastel.*

pencil
blue

oil pastels

light
green

dark
green

cream

watercolour
Cadmium
Orange

2 *Add a series of darker green pastel marks.*

3 *Wash over with a graded orange wash to expose the varied surface. Add shine using cream pastel.*

Yellow pepper

Peppers are also interesting to paint, as their surface is brightly coloured and shiny. After you've copied this one, try painting one cut in half, to show the intricate interior and all the seeds.

1 Draw the basic pepper shape and its curved stalk in pencil. Emphasize the deep crevices with red fibre-tip and colour the stalk with the light and dark greens.

2 Complete the shape by colouring it in with yellow, using orange for the deeper shaded areas.

3 Wash over the pen work with water to blend the colours gently. When dry, add highlights to the top and edges using cream and white pastels.

fibre-tip pens

orange red yellow light olive green dark olive green

pastels

cream white

EXERCISE Paint fruit

This is a simple combination of fruit to paint, but it is interesting as the fruits vary in colour and texture. Once you have tried this combination I suggest you choose a different variety and try painting them with the same materials.

1 Draw the fruit in with blue pencil. When painting a group of objects, place them together in a sympathetic pose, perhaps wrapping one around the other or overlapping them.

2 Press cream pastel on to the side of the tangerine, and add orange pastel markings for the texture. Draw a little light green pastel on the grapes and dark brown pastel to show the banana markings. Paint the banana Cadmium Yellow and the grapes green.

pastels

dark cream orange light
brown green

watercolours

Hooker's Yellow Cadmium Cobalt Burnt
Green Ochre Yellow Blue Sienna

3 *Paint the tangerine in Yellow Ochre and complete the orange pastel spotting. Deepen the shadowed area on the banana with brown paint. Use light green pastel to tip the banana at both ends, and accentuate its markings with additional dark brown pastel.*

4 *Paint around the fruit with a blue wash. Wash brown paint into the tangerine to heighten the texture marks.*

STILL LIFE

Have you ever sat at your kitchen table with brushes at the ready, wondering what to paint? Often there is something right under your nose waiting to be recognized as an ideal subject for your next work. Consider the objects around you – cups, plates, laundry basket – with their contrasting shapes and colours. Use your imagination and you will soon find something that will inspire you to get started.

Basket

Baskets can be treated as decorative items in their own right, or as containers for other still life objects. Look for those with interesting woven patterns and ridges.

1 *Draw the outline in with yellow pencil and paint the front of the basket and handle in yellow.*

2 *While this is still wet, paint the interior of the basket in brown, and flick some of this colour into the yellow to give it a mottled effect. Decorate the front and inside surfaces using a deep violet pencil.*

3 *Complete the pencil work, underplaying the details especially as they fade to the edges. Highlight the weave of the basket using the edge of the cream oil pastel.*

pencils

yellow ochre deep violet

watercolours

Yellow Ochre Burnt Sienna

oil pastel cream

Copper jug

When you combine objects for a still life study, they need to blend and contrast to give a balanced effect. A shiny surfaced prop such as this jug is ideal in a still life as it reflects the colours around it and unites the picture.

1 Draw in the jug shape with a violet pencil. Apply brown pencil for the dark reflected shapes, and masking fluid for the brilliant highlights.

pencils

violet brown yellow burnt sienna

pastel
brilliant orange

2 Fill in the shape with dry pencils: yellow, violet and burnt sienna.

3 Blend in the colours with a wetted brush, and whilst still damp re-emphasize the darks. When completely dry, rub off the masking fluid to reveal the highlights. Loosely draw the mid-tone reflections in burnt sienna. Add a shaft of brilliant orange pastel to the body, handle and base.

Exploiting the potential

The subject matter of your still life will dictate which media are best to use. This combination of fruit and vegetables scattered on patterned material and in a wooden trug is ideal to try out combinations of oil pastel resists and watercolour washes.

The wooden trug has an undercoating of yellow. Once dry, markings are added on top in burnt sienna and deep brown pencil to depict the grain of the wood.

The coloured cloth is initially blocked in using a loose pencil-work base with oil pastels adding a pattern, then washed over with various watercolour washes that diffuse some and highlight other areas, blending them in a colourful design.

The halved fruit flesh is primed with a loose coating of cream oil pastel, then covered with a watercolour wash of mixed pale green and yellow. The details are drawn in using pencils when the wash is dry.

EXERCISE Paint a still life

As you begin to form a composition using familiar objects, you will become aware of the wonderful variety of textures, shapes and patterns. These need to have an element of contrast and harmony for the painting to be successful.

1 *Draw in the still life using a brown pencil. With masking fluid in a ruling/drawing pen, detail in the highlights on the tea cup and saucer, the decoration on the hat band and the daisy.*

2 *Continue the masking fluid drawing in more detail to show the shape of the hat. Wash in the blue background, and introduce the green watercolour around the flower head and background.*

pencils

vermilion green dark
 brown

watercolours

Burnt Olive Yellow Cobalt
Sienna Green Ochre Blue

3 Complete the foreground in green watercolour, and drop in a blue shadow around the flower head and cup and saucer. Paint the hat and round biscuit in yellow, and the two chocolate biscuits brown. Use vermilion pencil for the design on the cup, and green for the grass beside the hat.

4 Complete the grasses around the different objects; this unites the background with the foreground. Rub off the masking fluid to expose the highlights on the hat, daisy and cup. The hat band and biscuit details are added with brown paint and dark brown and vermilion pencils.

FORM AND COMPOSITION

An outline is not enough to describe an object completely. To appear realistic, the object needs to have form and appear to be three-dimensional. The objects in your pictures also need to relate convincingly to each other, so the composition of the picture is also vitally important.

Making objects 3-D

Shadows help to describe the form of an object, and the object itself may have structure lines or markings within it that help. Let's see what I mean.

This circle is flat.

Placing a series of curved lines both up and around the circle gives it a feeling of roundness.

This ball has a series of lines that thicken as they come towards you: if these lines were exaggerated still further at the front, the ball would appear to be even more curved.

This cylinder appears flat as the shadows are not correct. Place in an arrow as a reminder of the light source.

Then readjust the shadows. Remember that light against dark shows form and shapes and makes an object look 3-D.

This carrot looks like a cylinder on its side. A darker line has been placed under it, giving a feeling of weight and stability.

This box looks odd because the shadows are falling the wrong way.

The shadows have been corrected to give contrast and depth.

The present has a ribbon that wraps around the whole structure, giving it form. The decoration colours appear light in the shadows and dark in the light. This also helps with the realism.

Tone

Each colour, whether it is pencil, pastel, ink or watercolour, has a range of tones. When painting tone on a subject, the correct tonal quality is vital for success.

In pencil or pastel work, tone can be created by a tightly massed network of lines, which can be loosened up for lighter effects.

In paint, thicker or neater watercolours are applied to give dark tones, and more water is added where a lighter tone is needed.

Here the image has been broken up into facets of tonal value. This is a simple tonal chart with white being number 1, and the darkest tone number 6. Try this out for yourself: place two objects in front of you and try to work out where the tones fall and which numbered tone each is. It is rather like fitting a jigsaw puzzle together.

Composition

Composition is another word for arrangement. In any subject, whether it is just one object or a collection of different objects, composition is of the utmost importance. There should be one main point of interest in your painting, called the 'focal point'. The darkest and lightest points are found here, it is the most detailed area, and if you are using colour the most colourful accent should be here. Proportions are also essential – the way groups of objects balance naturally with one another. A figure often helps to show the sizes of elements in the picture. Nearer objects always appear larger than distant ones.

You can include a feature that leads the eye to the focal point, such as an 's'-shaped, zigzag or 'c'-shaped path.

To choose your focal point, divide your paper rectangle into thirds both horizontally and vertically. There will be four points where the lines cross, and any one of these is an ideal place for your point of interest.

Here both the figure and dominant tree fall on a focal point (the top right). The grasses in the foreground are larger, giving depth to the picture. The s-shaped path leads the eye to the focal point.

Making the fenceposts larger and more accentuated in the foreground gives the impression of distance.

One subject – different approaches

An excellent way to explore the wide range of material mixtures is to try out one subject in a variety of ways, moving it around compositionally. I have chosen the corner of a cornfield. Each composition emphasizes the different ways you can tackle one subject. By brightening, darkening or detailing one point or by introducing an undulating line, the eye is carried to a different part of the picture.

The sky, background and tree are flowed in with washes of coloured inks on wetted paper. When partially dry, the corn and tree details are added with fibre-tip pens.

The texturing of the trees and cornfield is applied with pale oil pastel resist details. The use of several colours in the corn makes the contrast more exciting when the watercolour washes are applied.

The distant feel is created using a watercolour base, separating and darkening the foreground. Waterproof ink and soft pastel give the highlights and details, and the foreground ears of corn are enlarged to reinforce the feeling of space.

Non-waterproof black ink details of the trees, grasses and distant hills are washed over with watercolour. Whilst still very wet, salt is dropped into the watercolours, mottling the trees with the mid-distance and foreground corn. When it is dry the salt is rubbed off and a few more grasses are added to the foreground.

FLOWERS

One of the most popular of all subjects to paint is flowers. They are everywhere: outside our back doors, in a window box, at the local park, shop or supermarket. Flowers can also be silk or artificial, and these are ideal for a beginner as they do not fade or wilt between painting sessions.

Mixing greens

When you paint plants and flowers in watercolour you will need to mix different greens. I use many of the ready mixed greens available such as Hooker's, Sap or Viridian, and mix in a little Cadmium Yellow or Naples Yellow for the lightest greens, Cerulean, Cobalt Blue or Burnt Sienna for the mid-toned greens, and deep Violet, Alizarin Crimson or deep brown for the darkest greens.

2 Continue to paint the whole leaf and stalk, adding more green to the leaf edges.

1 Draw in the basic shapes in pencil and place masking fluid on the veins and stalk. Start painting a red wash over the dried masking fluid then, over the top, paint green with a little yellow.

3 When dry, rub the masking fluid off, and wash green over the exposed vein pattern. Paint the shadow in blue.

watercolours

Alizarin Crimson Olive Green Cadmium Yellow Cobalt Blue

Dandelions

Some flowers are at their most interesting at the seed stage, such as this dandelion. Try copying this example, then find a similar flower in seed, such as an 'Old Man's Beard' or a poppy head, to experiment with for yourself.

1 *Draw in the two heads, placing masking fluid details on one stalk, and drawing a circle of cream pastel on the second stalk. Apply pink oil pastel to the stalks.*

2 *Weave a little thread of green and orange oil pastel through the background as trailing weeds. Mix a dark green and mid-green background watercolour wash, and apply it over the picture.*

3 *When thoroughly dry, rub off the masking fluid. Splatter white gouache over the heads to soften the effect. Draw in the remaining details with a dry brown pencil.*

watercolours

Olive Green

Green Gold

oil pastels

cream

pink

pale green

orange

pencil brown

Daisies

This is another example of one subject tried out in a variety of ways. For the greatest contrasts, experiment with the different inks with watercolours, then add another medium such as pastels. I suggest that you practise drawing a few daisies in a sketch to capture the essence of the flowers before you begin.

The outlines are drawn using a sepia steel-nibbed pen. The whole surface is wetted and the yellow burst of flowers painted in: here they ran into the blue background. Some details are redrawn when dry, and some of the petals and leaves accentuated.

The daisies and leaves are sketched in using watersoluble sepia ink. When the background blue and greens are added for the leaves, the yellow of the flowers seeps into these colours and diffuses the watersoluble ink.

Strong strokes of brown, cream and orange oil pastels are used for the flower heads, and burnt sienna, light and deep green pastels for the foliage and stalks. A blue background is washed over, and this time the images spring through the watercolour wash. Extra details may be added whilst still wet.

Coloured paper can add 'mood' and gives the flowers an immediate tone. Yellow, white, cream, light and dark green oil pastels are used for the stalks and foliage. A dark wash of Olive Green and blue-green over the background allows the coloured paper to gleam through in places and unite the picture.

Poppy

Understanding how a flower is constructed is vital if you are to paint it correctly. The way the petals fit together and the way they blend or contrast is characteristic of a given bloom. Also study the background, as this will determine the tone and colour of the flower. Poppies are the loveliest of all flowers to paint. Note the way the bud is formed, and the tiny hairs on the stalks.

1 With a burnt sienna pencil, draw in the basic shapes of one poppy in full bloom with a grass sheath to add interest. Apply masking fluid to the bud, centre details, grass and stalk. Paint an initial yellow wash over part of the study.

2 Draw in details with sepia watersoluble ink. Add a dark green wash to the background, highlighting the poppy head shape. Start adding Vermilion to the flower.

3 Whilst still wet, add Magenta and more Vermilion to the whole head and bud, letting it diffuse the ink and run slightly into the other colours. Add petal creases and grass texture with more sepia ink. Rub off the masking fluid and soften the white patterns with light yellow, green or watery Vermilion.

watercolours

pencil
burnt
sienna

water-
soluble
ink
sepia

Yellow
Ochre

Olive
Green

Vermilion

Magenta

Tulip

Flowers have natural flowing shapes, and as you practise these shapes your painting will become more fluent, and you will gain the confidence to work more freely. Tulip petals wrap smoothly around each other, and they are gorgeous to paint, particularly when they start to droop their heads.

1 *Start by drawing in the egg-shaped head of the tulip and flow of the petals in vermilion pencil. Add a pale green stalk.*

2 *Add more deeper colours and patterning by drawing yellow soft pastel and red pencil marking on each petal, and green pencil up the stalk.*

pencils

vermilion pale green

soft
pastel
yellow

3 *Wash over the whole flower head with water and let the colours slightly mix together. Once it is dry, redraw the red markings and reapply the yellow pastel. This describes the form without the use of shading.*

Grouping flowers

Painting a couple of heads of the same flower gives you the opportunity to combine proportions, tones, colours and shapes.

The soft 'halo' effect on the poppies was created by wetting the edges with water before starting to paint the petals. One flower is more dominant and colourful, the other like a softer silhouette.

These sunflowers are in contrasting but complementary tones. The leaves are drawn in emerald and olive soft pastels, the flower petals and centres in orange, burnt sienna and brown. Yellow watercolours give the basic flower colour and some details are outlined with a brown pencil. For the leaf texture, pastels are added to dried watercolour.

Dandelion heads

This completed picture contains several of the same variety of seed head, created using different painting methods, plus the flower, leaves and buds. It is a delightful array of mixed media.

The top left-hand seed head is created using salt sprinkled into the dark background while it is still wet.

Here cream oil pastel resists the wash.

This shape is dabbed out using a tissue and splattered with some white gouache.

The random seeds (dandelion clocks) are created with salt dropped into the wet background wash and allowed to dry before working on their details.

GARDENS

Next we turn to the subject of gardens, and some of the features that you can learn to paint and then perhaps combine with some of the flowers you have been practising. Many garden features require careful observation of textures and shapes.

Path

Let's start with a very basic component that links many garden elements together: a path. Paths can be constructed from bricks, stones, cement or ornamental stone.

1 *Sketch the path and gate in pencil, then draw over with a brush pen. Note how the farther blocks have little detail, giving a feeling of distance and recession to the path. Begin drawing in the lawn area in green pencil.*

2 *Colour in the remaining lawn around the path, adding some yellow pencil. Add a little cobalt blue shading to the distant path.*

3 *Wash over the whole area with water and let the colours mould. Draw in more grasses in green pencil, larger in the foreground and smaller in the distance.*

brush
pen
black

pencils

green yellow cobalt
 ochre blue

Fountain

A fountain is an enchanting garden decoration. It is a challenge to reproduce the materials from which it is made, such as stone or cement, and the patterning of the water that sprays from it.

1 *Begin in pencil with the main shape of the bowl, stem and water spouting from the centre.*

2 *Add a little masking fluid to the falling water, the splashing on the brim of the fountain, and the grasses below. Colour the shapes in with a grey pencil and wash in the background in dark green.*

3 *Complete the background with yellow, and draw in the grasses with detailed pencil work at the base. Rub off the masking fluid, and paint over the white flowing water with watery white gouache to give a fuller water spout.*

pencil
grey

watercolours

Olive Green Cadmium Yellow

Brickwork

Studying the structure and texture of the material of any subject you choose is essential, and brickwork is a very good example of this. The colours vary considerably, and weathering and ageing of the bricks makes garden walls and paths more interesting. These examples have been painted on a sandy pastel paper.

a) Bricks and mortar are outlined in oil pastels, which act as a resist to the darker watercolours applied over the top.

b) Soft pastels are applied to the brick shapes and the mortar, and ink details added afterwards.

c) Assorted watersoluble pencil shavings are splintered into the wet brick shapes so that they mingle, and grey watercolour mortar is then added.

d) Waterproof and watersoluble inks are used for the brickwork, with grey watercolour for the mortar.

e) Watercolours are applied wet-into-wet for the bricks, with white gouache mortar.

f) Masking fluid is used for the mortar shapes, the bricks are added in watercolour then the masking fluid is rubbed off.

Garden steps

Steps are a useful device as they link different parts of a picture together, and connect objects at different heights.

1 *Sketch in the main varying heights with a yellow pencil. Imagine the separate bricks that are needed to construct these steps, then ink them in with waterproof and watersoluble sepia pens.*

2 *Using pale grey, pale and bright orange and pale green oil pastels, add the rough texture on the brick surfaces.*

pencil
yellow

water-
soluble
pen
sepia

water-
proof
pen
sepia

oil pastels

watercolours

pale
grey

pale
orange

bright
orange

pale
green

Violet

Burnt
Sienna

3 *Wash over the whole area with a mixture of Violet and brown watercolour, blending in all the inks and uniting the pastel work. Finally, place more details on the grasses and bricks in the walls using pastels.*

Spider's web

As you venture further and explore your garden, the variety and choice of subjects widens. Corners reveal even more unexpected objects for you to paint: a beautiful example is this spider's web.

The web and edges and centres of the dog roses are carefully drawn in with masking fluid.

The background has an undercoating of pale yellow with Magenta watercolours (very watery). When this is dry the flowers and leaves are painted in.

The foliage behind the web and flowers is kept very dark so that the features designed in masking fluid will be highlighted when the fluid is rubbed off.

Once the masking fluid has been removed, the exposed details of the flowers are washed over using a mix of pale yellow and pink. A blue wash is used over the web.

Garden well

What a wealth of rich textures and materials – bricks, wood, foliage, stones and slates – all in one small corner of the garden. When your subject is complicated like this, try to keep your materials as simple as possible.

An undercoat of grey and Burnt Sienna is applied to the roof of the well, first mottling the wash so that it becomes uneven and blotchy. When it is dry, the slate shapes are applied with brown and violet pencil. Cream oil pastel is dragged over the surface to add light and a weathered effect.

The shapes and textures of the ferns are drawn in with masking fluid and oil pastels in pale greens. The background repeats the feathery patterns but in a dark green watercolour with Violet added for the depth and shade.

Stone shapes are drawn in using grey and brown pencils: some are wetted and some kept dry.

The light grasses are added in masking fluid and the darker grasses are in pencil, blues and browns. The yellow flowers are added in oil pastel, with green for the stalks.

AT A GLANCE...

1 Begin by sketching in the main features of the gate, steps, arch, wall and foliage. Check that the stairs are parallel to one another. Try to get some contrast between the foliage leaves either side of the steps.

2 Paint a Yellow Ochre watercolour wash over the wall, the distant garden and step areas and, whilst still wet, drop in brown to add interest to the brick texturing (wet-into-wet).

The palette

watercolours

Yellow Ochre Burnt Sienna Cadmium Yellow Olive Green Cerulean Violet

brush pen
black

3 *When dry, use a black waterproof brush pen to add details to the railing, foliage and branches over the arch and around the steps, defining the obvious differences in assorted leaves.*

4 *When the ink is thoroughly dry, paint blue into the sky sections and whilst still damp mix green with Cadmium Yellow for the initial wash over the foliage on the arch and either side of the steps.*

Detail: *Within this area lie all the essentials to highlight using your inks: the stones, the foliage and the strong gate design, as well as the depth created by the long watercolour shadows.*

5 *Using the brush pen again, add some more drawing to the foliage over the archway and around the steps. Add the structure of the ornate gate, keeping the lines vertical, otherwise it will look as though it is falling over! Then add the stones in the wall, and draw horizontal lines on the steps.*

6 **Finished picture:** *300 gsm (140 lb) Not watercolour paper, 40 x 30 cm (16 x 12 in). Complete the distant view through the gate using blue plus a little Violet. Deepen the shadowed areas of foliage using green mixed with a little Violet in 'dabbing' marks. Paint this under the canopy of the arch and around the steps. Mix Violet, blue and a spot of brown for the shadows that form the main feature of the whole painting. Looking carefully at the angle of these, paint in the shades so that the shadows fall down the walls, deepen the foliage, shade the right hand side of the arch and fall full across the gateway, and over the steps, just leaving the tops highlighted in the sunshine.*

TREES

Trees are the very essence of the countryside. To make your trees convincing, the basic structures of trunk, branches, twigs, and leaf textures and colours all need to be carefully studied. Observing a deciduous tree in winter is the easiest time, as they become quite daunting when clothed in a mass of foliage.

Basic steps

There are three main stages to drawing a tree successfully. First you will need to observe the outline, then the pattern and finally the structure.

outline

Look hard at the patterns within the tree: how do the lines within the tree flow?

pattern

Try drawing a tree starting with the basic outline. Even within a variety, individual trees tend to differ.

Elaborate the structure by defining areas of light and shade.

structure

Simplifying trees

Although they appear very complicated, don't try to reproduce vast details of foliage and branches, just some accurate suggestions.

Instant branches can be created with a brown watersoluble pencil, starting with the thicker ones and tapering to the twigs. Add leaves (dabs of green oil pastel), making sure they cover some of the branches.

Do plenty of sketches of the way trees grow, how they appear to become 3-D, tones needed to make them appear real, the contrasts between dark and light. Branches can change tone several times compared with others in the background and foreground. This illustration is done with a blue steel-nibbed pen.

Interpreting the surfaces of the foliage will help to show the tree's character. The shape of the masses of fringing leaves gives each tree a distinct feel and the differences in the varieties are easy to see. These felt-tip sketches are of a Scots pine, a Prunus and a plane tree.

Different trees

Trees present many different faces – bare branches, blossom, full leaf – and are always an interesting picture to capture. Try to keep things simple and see how individual trees vary, sometimes dramatically, in colour, tone and texture.

This tree in blossom is painted using dabs of pink oil pastel for the blossoms, which act as a resist to the green and burnt sienna ink and watercolours in the leaves and branches.

Blue and green watersoluble pencils with watersoluble sepia ink are feathered into graceful tapering shapes to give the upwards flowing foliage of a conifer.

The dense, spiky foliage of black ink and contrast of masking fluid details against the light green and Cerulean watercolour washes create this holly tree.

Trees in the landscape

Trees give the feeling of size. soften edges and conjure up interesting shapes in your paintings and help to create a satisfying composition.

When trees are massed together, keep the overall shapes simple. The distant hills are just a silhouette. emphasizing the details in the trees. This is drawn with watercolours and felt-tips.

Trees surround and enfold a building, softening the otherwise rigid shapes. The result is like a jigsaw puzzle. The watercolour pencils used in this sketch are partly diffused with water.

Trees on their own need to be accurate impressions, dramatic, and possibly forming a focal point. Introducing a fence or figure will give you a feeling of how large or small the tree is, and add perspective.

Seasonal changes

In a temperate climate the changing seasons bring with them dramatic changes in the trees, which have a wide range of different colours and textures at different stages through the year.

Spring. The tree framework is painted in over a brief sketch, lightening the branches and thinning them with watery Raw Umber watercolour. Leaf Green is used for the leaves, and the colour is splattered on to show the fresh young foliage.

Summer. The main trunk and some of the branches are drawn in sepia watersoluble pencil. The bulk of the foliage is painted using Olive Green and Cobalt Blue watercolours, with salt painted on when still wet. When the paint has dried, this is brushed off and the remaining branches drawn in with dry pencil.

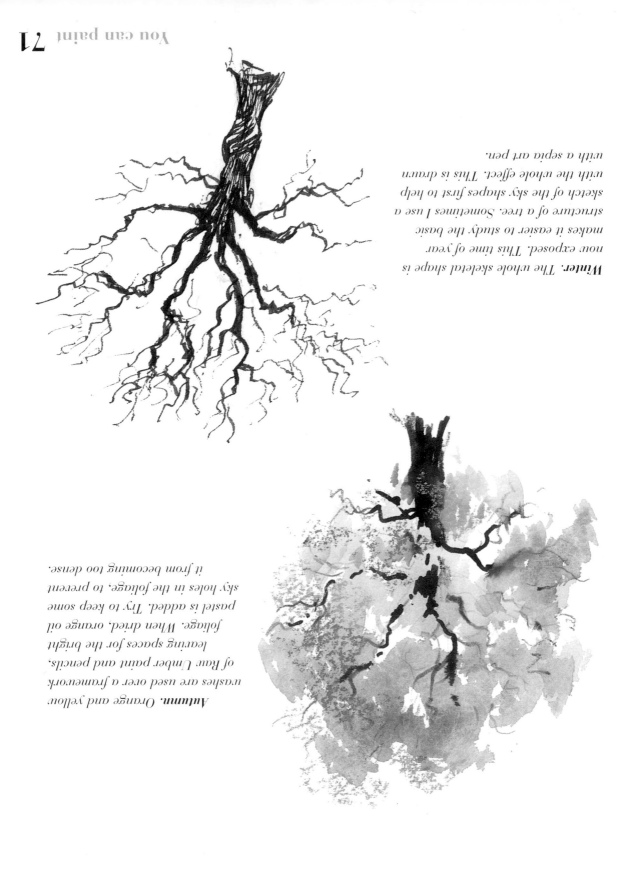

Winter. The whole skeletal shape is now exposed. This time of year makes it easier to study the basic structure of a tree. Sometimes I use a sketch of the sky shapes first to help with the whole effect. This is drawn with a sepia art pen.

Autumn. Orange and yellow washes are used over a framework of Raw Umber paint and pencils, leaving spaces for the bright foliage. When dried, orange oil pastel is added. Try to keep some sky holes in the foliage, to prevent it from becoming too dense.

Silver birch. *Using watersoluble pencils, slender lines of yellow ochre, grey and browns are drawn in to connect the abstract dark brown shapes. A wash is added to soften the contrasts.*

Sycamore. *The lines and rectangles are detailed in assorted shapes and sizes using a black waterproof pen, and this is covered by a grey and Violet watercolour wash.*

Scots pine. *An attractive mix of brown, orange and yellow watercolours are painted in a massed flurry of circles, ovals and blocks. A watersoluble sepia pen diffused with these colours. The more definite shapes were detailed in with sepia once the picture was dry.*

Like the leaves, the trunk is characteristic of the variety of tree and needs careful observation.

surfaced, peeling in strips or thick and fibrous in texture: the amazing variety is breathtaking.

A tree's trunk is its protective armour. Tree trunks can be smooth, deeply fissured, metallic-

Tree trunks

Autumn leaves

What an event autumn is! I always love painting the colours of this season: russet, oranges, reds, yellows and browns.

Masking fluid is used for the pale veins and wet watersoluble pencils are mottled together for the leaf surface. Traditional yellow pastels are applied to show the drying leaf sections.

The different parts of this leaf are sketched in dry watersoluble pencils, with small details in sepia waterproof pen. The violet, orange, pink and red are varied to contrast the different sections.

A similar leaf, drawn in another technique using wetted traditional pastels and fibre-tip pens for the veins. The leaves are outlined with brown to add contrast and strength to the leaf shapes.

EXERCISE Paint an autumn tree

Try copying this autumn tree, which uses salt for the foliage effect. I am sure you will enjoy the exercise. Then find a similar one to try for yourself. Remember not to overwork your trees; you need only give an impression of the mass of foliage.

1 Use a 2B pencil to establish the main shapes, noting any spaces between the branches (these give character) and comparing the length of the branches with the trunk to get the proportions correct.

2 Complete the drawing and place on masking fluid for the light foliage and the edges of the trunk, as well as a suggestion of grasses. Emphasize the movement of the branches using sepia waterproof pen. Start painting in the trunk using grey and the sky with blue watercolours.

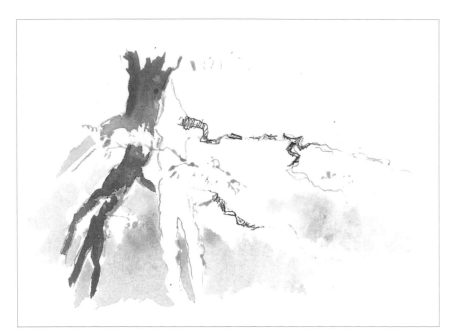

The palette

watercolours

waterproof
pen
sepia

Neutral Cerulean Cadmium Cadmium Burnt Violet
Grey Orange Yellow Sienna

3 Complete the trunk and add more branches in ink. Dampen the paper over the foliage area, apply a very watery wash of orange, yellow and brown, then sprinkle in table salt. When completely dry, rub off the salt and masking fluid.

4 Paint in the base of the tree with brown, and darken the trunk using Violet. Detail in more branches using ink, and gently soften the light areas of masking fluid with pale yellow watercolour.

SEASIDE

The sea, the shores and the coastlines are wonderful subjects that offer many unrivalled possibilities for the painter. The drama and mood of the water and waves, the curves and sweeps of the sandy seascapes, and the intimate crevasses of the rockpools are just some of the treasures.

Reflections

Painting successful seas requires much patient studying. Spend time watching waves and reflections and jot down some of your observations.

A boat in full sail: the reflection resembles a slightly rippling mirror. The slight waves are thicker as they get closer to you, and compress as they near the boat.

When wind ruffles the water surface and the boat starts to move more quickly, the whole reflection crinkles and buckles into jagged patterns.

The size of the reflection always mirrors the size of the object, even when there is some shoreline in front of the object.

Evening sail

This picture captures the complexity of reflected images and light and the sweeping feeling of distance and space that is the very essence of a seascape. Everything is echoed from above in the sea's surface, so the reflections have to be simplified and dramatized.

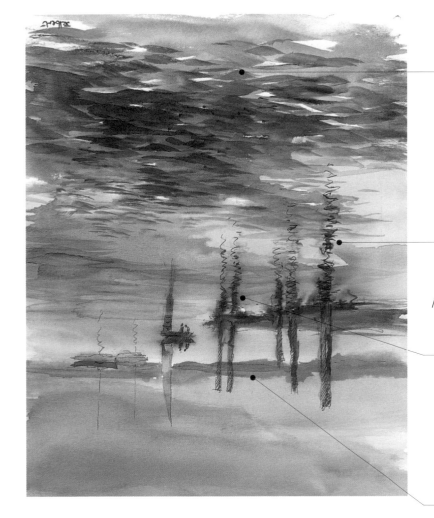

Note the size of the foreground waves: larger with more movement. As they melt into the distance they diminish in size, eventually becoming smooth, but always reflecting shapes of the tone and colour of the sky above.

The pale reflections are extended and made more jagged to capture the feeling of depth and undulating water.

The reflections of the boats and piles are darkened to emphasize the brightness and lightness of the sea's surface.

Keeping the distance as a silhouette helps to highlight the main features such as the boat with the sails and its figures.

EXERCISE Paint a seascape

A lasting memory of the seaside is the tumbling and unfurling waves. Each unravels and splashes against rocks and along the shore. I have tried to capture this movement and bring the sea to life in this exercise.

2 Mixing a brown using Raw Umber and a little Cerulean watercolour, paint in the mid-distance rocks, slightly misting the edges where the top of the wave will come. Paint in the underside of the wave with Cerulean.

1 Using a 2B pencil, lightly rough in the main elements of the waves and rocks.

3 *Use Cobalt Blue for the distant stretch of sea to contrast with the foreground wave. Paint Neutral Grey into the sky shape, grading it so it is darker towards the sea, and blending it with a little Cerulean on the left.*

4 *Darken the underside of the waves with an additional wash of Cerulean and Cobalt Blue. When it is dry, splatter watery white gouache against the wave edges for the spray. Add small directional lines of Cobalt Blue to the foreground wave to complete the picture.*

Orange and Violet watercolours are painted into the main shape, emphasizing the texture and structure. Ultramarine is added to the shadows.

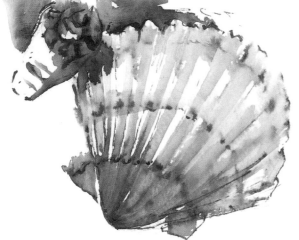

The main skeleton is drawn in using a brush pen, then coloured using dry orange, purple and yellow watersoluble pencils, scribbling them in to give a loose hint of colour.

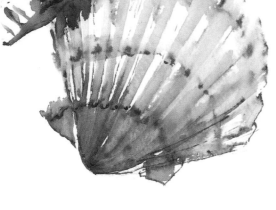

Here the shells are inked in using an art pen with a sepia watersoluble pencil drawing. A little purple watercolour is washed over and more pigment added to the shadows. Pale Yellow Ochre is painted into the shell's grooves.

Shells are a delight to look at and a treasure trove for the painter. Collect a few, from the beach or from the marvellous selections in many seaside gift shops, and try out this exercise using different shapes. This is another example of approaching the same subject using different media.

Shells

Shrimp

Fascinating creatures are found in the sea: starfish. crabs. lobsters. fish. limpets. sea anemones and shrimps. Each deserves to be painted and recorded in your sketchbook. I have chosen a shrimp. a cooked one from my fishmonger as it is such a dramatic colour.

1 Begin in pencil with the main basic shape. and ink in the large dark eye. Draw the back scales and tail details in pink.

watersoluble pencils

pink

orange

burnt sienna

waterproof ink
sepia

2 Add the body colour in pink and more details with orange pencil and sepia ink.

3 Outline the body with dark red-brown. and wash over the whole shrimp with water. blending the colours gently together. When dry. add dry orange and burnt sienna and further ink to give the shrimp its form and structure.

Rough sea

To pluck an image from the forces of nature is exciting and challenging. The sea can be calm, inviting and friendly as caressing waves, or ferocious, as in this picture *The Rough Sea.*

Yellow Ochre watercolour is underpainted on the rocks and shoreline. When dry the tones of the rocks are painted with Raw Umber and a little salt sprinkled on to mottle the image.

Masking fluid is applied to some of the waves and foreground sea. The next step is painted in one go, very quickly: the paper is wetted and Viridian Green, Cobalt Blue and Ultramarine applied to the distance and foreground sea and waves. More salt is sprinkled on to create the effect of splashing water. When dry, the masking fluid is rubbed off.

When thoroughly dry, the salt is rubbed off, and the white massed spray shapes painted in with white gouache. Pale blue paint (Cobalt Blue watercolour mixed with white gouache) is splattered over the rocks and sky to complete the picture.

Seaweed and pebbles

Pebbles are the sea's gorgeous jewellery, and seaweed its underwater forest, a lucrative combination for the painter. When exposed at low tide both are a testament to the variety and complexity of marine life. They offer an endless source of inspiration for mixing different media.

This matted growth of bladderwracks with their inflated oval fronds and bladders are a familiar sight on rocks and seashore in the summer. Olive Green, Burnt Sienna and Cobalt Blue watercolours are painted with a narrow brush to show the weeds, rocks, stones and distance. The stones in the foreground are splattered in with Sienna, and the highlights on the seaweed dotted in using cream oil pastel.

This red feathered seaweed common in rockpools at low tide clings to shells and stones. Masking fluid and sepia watersoluble ink are used for the initial details. More details are then added with a waterproof sepia pen. After wetting the whole drawing with water and letting it dry, the masking fluid is rubbed off and a watercolour wash of light Yellow Ochre is painted over to unite the whole picture.

*Kelps are the
most familiar
brown seaweeds
that anchor on to larger
stones and rise in arches
from the water like flying
fish. Yellow ochre, burnt
sienna and sepia water-
soluble pencils are used with
grey oil pastels for the stone
texturing. Everything is kept dry,
except the cobalt blue added from
the tip of a watersoluble pencil with
a brush for the distant sea.*

*This delicate form of ribboned wracks
has forked blades. Soft orange pastels
are used here over grey, green and
Violet watercolours with details loosely
added using green and brown
watersoluble pencils.*

DEMONSTRATION ROCKPOOLS

AT A GLANCE...

1 Draw in the scene with a brown pencil. Keep the shapes simple and bold, using horizontal strokes in the distance.

2 Block in the first structure of the rockpools using strokes of burnt sienna pastels in light touches, leaving some of the paper colour showing through. Add light blue-violet to the sky in upward sweeps.

The palette

pencils pastels

ochre sea sienna
 green

blue- burnt pink- raw yellow-
violet sienna grey umber green

Hooker's light turquoise cadmium
green cobalt blue yellow

3 *Keeping the planes of the rocks simple, add pink-grey and raw umber, creating a light and darker side to the rock formation.*

4 *Apply bright yellow-green for the rock tops and weeds, and Hooker's green for the sides and water reflections. Draw the distant waves in light cobalt blue. The details of the reflections and rock structures are drawn in sea green, ochre and sienna watersoluble pencils.*

5 *Highlight more of the rock structure with the pencils, in particular outlining most of the rocks, and defining and contrasting edges and surfaces with the ochre and sea green. Place more pink-grey pastel into the water and deepen the Hooker's green pastel work in the reflections. Add turquoise pastel to the distant strip of sea across the horizon.*

Detail: *This detail shows the array of tones and abstract shapes needed to create the illusion of rocks butting up to one another with the addition of reflections of light and dark zigzagging pastels in the water area.*

6 ***Finished picture:*** *blue-grey pastel paper,*
28 x 36 cm (11 x 14 in). Add more lights to
the whole scene: white pastel strokes on the
waves in the distance, applied more heavily to
the foreground water reflection. Using cadmium
yellow 'dabs', highlight some of the weed to the
left side, and emphasize the light greens in the
whole picture. Add a touch of cobalt blue to the
foreground pool and into the top of the sky area.

BUILDINGS

Buildings need to be drawn accurately or your paintings will be unconvincing. Perspective is vital, but is a complex subject: the more observing and sketching you do the better able you will be to get the perspective right. Often when you get the shapes of the landscape, sky or water around your buildings correct, the buildings themselves will look right. When drawn successfully, a building or part of a building forms a stunning focal point for a picture.

Window with net curtains

Let's start with one feature of a building: a window. You need to be accurate when you portray a window's construction and shape, but your painting can be looser and more interesting when you add details such as these curtains.

1 *Draw in the main details. Apply masking fluid to the net curtain details. Start painting in the surrounding brickwork.*

2 *Paint in the window area using a mixture of brown and dark blue watercolour. Place in the bricks with orange oil pastels.*

3 *Rub off the masking fluid. Apply up to three watery washes of white gouache over the curtains. Let each wash dry before applying the next. Complete the brickwork using orange, red and yellow watercolours and orange oil pastels.*

watercolours

Alizarin Crimson • Burnt Sienna • Indigo • Cadmium Orange • Yellow Ochre

oil pastel orange

Farm doorway

Another useful subject is a doorway, which, once you gain confidence, can be drawn to include people, animals, plants or garden implements in future work.

1 *Draw in the main features. With a brown watersoluble pencil, emphasize the door frame plus the start of the stonework. Apply masking fluid to the chicken wire in the top section, and to the grasses at the base of the door.*

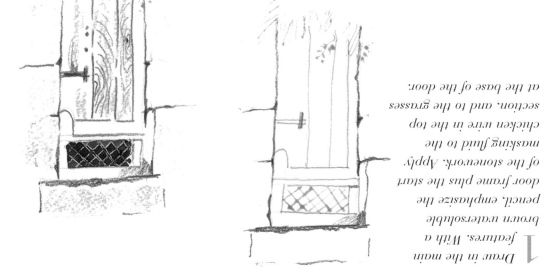

2 *Loosely apply cream and grey oil pastels to the stones and door. Using burnt sienna and watersoluble pencil, draw in the rusty hinge and nail heads, plus the wood grain on the door. Paint a dark grey over the top window section.*

3 *Wash Neutral Grey watercolour across the stonework to emphasize the oil pastel work. Rub off the masking fluid, and paint blue on the door and green over the grasses.*

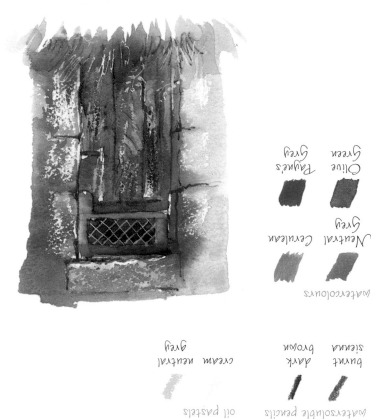

watercolours

Neutral Grey Cerulean

Payne's Grey Olive Green

watersoluble pencils oil pastels

burnt sienna dark brown cream neutral grey

Pantiles are fabulous tiles that interlock to form ridges and patterns that are a joy to look at, but not easy to represent! Watersoluble sepia ink outlines these tiles, and Violet and orange watercolours fill in the roof colour.

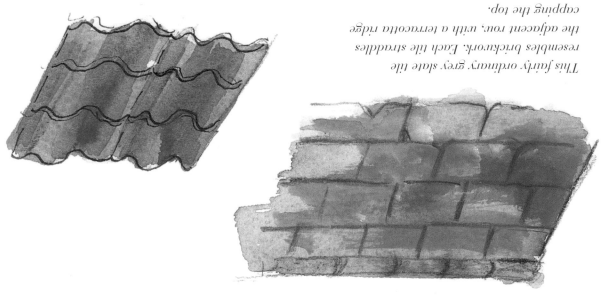

One tile clips over the next, forming an interesting flowing pattern. These are drawn in watersoluble inks with orange watercolours.

This fairly ordinary grey slate tile resembles brickwork. Each tile straddles the adjacent row, with a terracotta ridge capping the top.

Roofs

Each section of a building has its individual style, design and materials. Look hard at the colour, texture and structure of different roofs. It is amazing just observing their colours, and the way the tiles slot into and jut up to each other. Try out several versions for yourself.

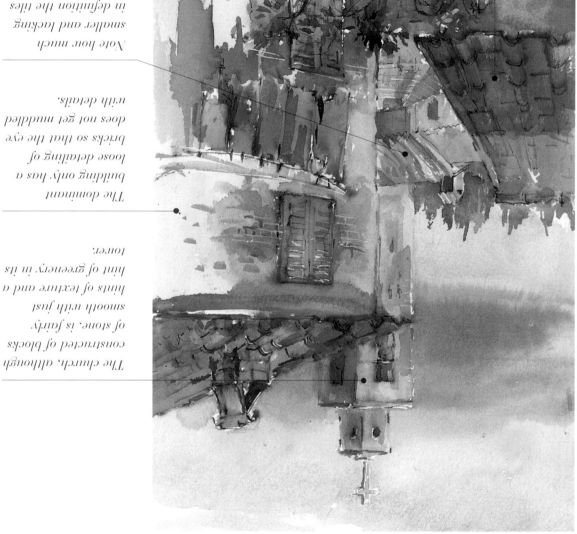

The roofing was similar to the pantile illustration opposite, although the tiles on the left are a slightly different shape than those on the right. Always be on the lookout for differences, and don't rely on stereotypes.

Note how much smaller and lacking in definition the tiles become as the roofs move away to the distance.

The dominant building only has a loose detailing of bricks so that the eye does not get muddled with details.

The church, although constructed of blocks of stone, is fairly smooth with just hints of texture and a hint of greenery in its tower.

Lake Trasimeno

When taking some students to Italy, this was one of the demonstration pictures I did with them, to display various features of buildings.

DEMONSTRATION CHURCH

AT A GLANCE...

1 Sketch in the main details. Apply masking fluid to the roof, tops of the tombstones, grasses, church clock and windows. Add the dark areas with a sepia watersoluble pen. Apply yellow and pale green oil pastels to the grass areas.

2 Paint the sky Cerulean. Mix green and Cerulean for trees, adding Cobalt Blue to those on the right with a little yellow at the top and in the front tombstones. Darken windows and clock in Cobalt Blue, add brown plus yellow for the other tombstones. Paint the roof brown.

The palette

watersoluble pen

sepia

oil pastels

cream pale green yellow

pencils

burnt sienna cedar green sea green

watercolours

Cerulean Olive Green Cobalt Blue Burnt Sienna Yellow Ochre

3 *When completely dry, paint in the middle distance using yellow and a touch of green. Adding more Cerulean, place in the foreground, and paint in the small tree details. Paint the church a mix of yellow, brown and a little Cerulean.*

4 *When dried thoroughly rub off the masking fluid leaving the detailed white paper. Gently merge the light areas into the background, brushing over yellow watercolours.*

5 *Finished picture:* white 300 gsm (140 lb)
watercolour paper, 28 x 36 cm (11 x 14 in).
*Using sea green pencil, detail in the final stages
of the small foreground tree. Pencil in some
foreground grasses using cedar green and burnt
sienna. For extra light apply the cream pastel
gently over the distant tree surfaces, roof and
tombstones. Re-state the undulating shadows
connecting the front tombstones using Cobalt
Blue with green watercolour.*